Jo my

MH88756548

and always makes me
laugh and giggle and have
fux. Bless you, My Inind.

Love ya

Patti

First published in Great Britain in 2019 by Pyramid, an imprint of Octopus Publishing Group Ltd, a Hachette UK Company.

Don't Give a Fig. Copyright © 2019 by Octopus Publishing Group Ltd.

All rights reserved. No part of this book may be used or reproduced in any manner whatsoever without written permission except in the case of brief quotations embodied in critical articles and reviews. For information address Harper Design, 195 Broadway, New York, New York 10007.

HarperCollins books may be purchased for educational, business, or sales promotional use. For information please email the Special Markets Department at SPsales@harpercollins.com.

Published in 2020 by Harper Design An Imprint of HarperCollinsPublishers 195 Broadway New York, New York 10007 Tel: (212) 207-7000 Fax: (855) 746-6023 harperdesign@harpercollins.com www.hc.com

Distributed throughout North America by HarperCollins Publishers 195 Broadway New York, New York 10007

ISBN 978-0-06-299521-6 Library of Congress Control Number has been applied for.

Printed in Singapore First Printing, 2020

DON'T GIVE A FIG

words of wisdom for when life gives you lemons

TO:																	 				
FROM:																 	 				

NO PAIN NO GRAIN

ASPARAGUS THE DETAILS, IT'S THYME TO MOVE ON

WHEN LIFE GIVES YOU LEMONS,
MAKE LIKE A BANANA AND SPLIT

DON'T LET IT RYEL YOU UP

DRAW A LIME IN THE SAND AND LET NO ONE CROSS IT

NEVER AGRAIN

IT'S NO BIG DILL

IT WAS THYME FOR A CHANGE ANYWAY

RICE UP!

I SAID TOMAYTO,
HE SAID TOMAHTO,
SO I SAID FIG OFF

CHOI TO THE WORLD!

LET THAT SHIITAKE GO

"NEAR, FAR, WHEREVER YOU ARE, I BELIEVE THAT THE ARTICHOKE DOES GO ON"

REZEST MUCH OBEY LITTLE

DON'T LET IT GET JALAPENO BUSINESS

KALE SERA, SERA

WHEN YOU FEEL LIKE YOU HAVEN'T BEAN CURD, SHOUT LOUDER

ALWAYS BEETROOT TO YOURSELF BECAUSE THERE ARE VERY FEW PEOPLE WHO WILL ALWAYS BEETROOT TO YOU

"LIVE AS IF YOU WERE TO DIE TOMARROW"

GANDHI

BROCCOLEAVE ME THE HELL ALONE

LEARN FROM YESTERDAY LIVE FOR TODAY HOPE FOR TOMARROW

"PAPRIKA DON'T PREACH"

AIN'T NOBODY GOT THYME FOR THAT

LET'S TAKE THIS SPROUTSIDE

A SINGALONG TO MAKE IT BETTER

"CHIA-CHIA-CHIA-CHANGES"

• • •

#wejammin

YOU WALNUT BE BROKEN

HERE TODAY, TARRAGON TOMORROW

GO CARPE THE SHIITAKE OUT OF THIS DIEM

YOU WANNA PEACH OF ME, BEETS?

JUST BEET IT

DO WHAT MATTERS.
FIGET THE REST

KEEP YOUR FRIENDS CLOSE AND YOUR ENDIVES CLOSER

REVENGE IS SWEDE

SHIITAKE HAPPENS

DON'T GIVE A DAMSON

HOW DO YOU LIKE THEM **APPLES?**

JUST BE YOU,

AND IF PEOPLE DON'T

LIKE IT, WELL, FIG 'EM

PEAS FIG OFF

GO, MAN GO!

GET RID OF YOUR EXCESS CABBAGE

DON'T LET LIFE BEET YOU DOWN

#likaleyeah

BEAN THERE,

DONE THAT,

GOT THE PEA SHIRT

IT'S NOT YOUR CRESS TO BEAR

REMEMBER, YOU ALWAYS HAVE A CHOYS

YOU'RE AS DRAMATIC AS A SOAP OKRA

#beetdown

NEVER PUT THE KIWI TO YOUR HAPPINESS IN SOMEBODY ELSE'S POCKET

KILL THEM
WITH SUCCESS,
BERRY THEM
WITH A SMILE

"BLIND BAYLEAF IS DANGEROUS"

PROVERB

WHAT DOESN'T KALE YOU MAKES YOU STRONGER

PEACH, DON'T KILL MY VIBE

IT AIN'T OVER LENTIL IT'S OVER

HATERS GONNA HATE. POTATAOES GONNA POTATE

GIVE ME ONE GOOD RAISIN WHY I SHOULD FIGIVE YOU

KEEP THINGS IN PEARSPECTIVE

FIGHT THE GOURD FIGHT

YOU ARE NOT PEARANOID

OH KALE YOU WIN

IF THEY'RE SO CHARD TO LOVE...

...LET THAT (WO)MANGO

KNOW YOUR LIMIT. DO NOT CROSS THE LIME

IF LOOKS COULD KALE

"IN MATTERS OF STYLE, SWIM WITH THE CURRANT IN MATTERS OF PRINCIPLE, STAND LIKE A ROCK"

TAKE IT SLOE

"BAYLEAF HAS THE POWER TO CHANGE YOUR INNER STATE AND YOUR OUTER WORLD"

WHATEVER HAPPENS, ROMAINE CALM

WHEN NOTHING GOES RYET, GO LEFT

"LORD DON'T SLOE ME DOWN"

WHEN IN ROME, DO AS THE ROMAINES DO

YOU'RE THE BOSS THAT CAN'T BE BEET

"OH GOURD WON'T YOU BUY ME A MERCEDES BENZ"

YEAH YOU'VE GOT SASS.

THEY NEED TO DILL WITH IT

#dillbreaker

THIS IS BUILDING TO A CRESSENDO

GOOD THINGS

COME TO

THOSE WHO WHEAT

TATERS GONNA TATE

DON'T CARROT ALL

#wheatever

For those of you who haven't herb enough, and haven't herb-it-all-bivore, this series has all the chiaing things you've ever wanted to say in vegan-friendly puns.*

Find the pearfect gift for any occasion:

AVOCUDDLE

comfort words for when you're feeling downbeet

YOU ARE 24 CARROT GOLD
words of love for someone who's
worth their weight in root vegetables

I AM GRAPEFUL
all the good thymes I want to
thank you for

*Or plant-based puns if, like us, you are no longer sure if avocados are vegan. Or friendly.

comfort words for when you're feeling downbeet

I AM GRAPEFUL

all the good thymes I want to thank you for

DILLON AND KALE SPROUTS